IMAGES
of America

THE HOPI PEOPLE

On the Cover: Hopi Native Americans are pictured on the rim of the Grand Canyon. (Courtesy Arizona Historical Foundation.)

IMAGES of America

THE HOPI PEOPLE

Stewart B. Koyiyumptewa,
Carolyn O'Bagy Davis,
and the Hopi Cultural Preservation Office

ARCADIA
PUBLISHING

Copyright © 2009 by Stewart B. Koyiyumptewa, Carolyn O'Bagy Davis, and the Hopi Cultural
 Preservation Office
ISBN 978-0-7385-5648-2

Published by Arcadia Publishing
Charleston SC, Chicago IL, Portsmouth NH, San Francisco CA

Printed in the United States of America

Library of Congress Control Number: 2008924290

For all general information contact Arcadia Publishing at:
Telephone 843-853-2070
Fax 843-853-0044
E-mail sales@arcadiapublishing.com
For customer service and orders:
Toll-Free 1-888-313-2665

Visit us on the Internet at www.arcadiapublishing.com

CONTENTS

Acknowledgments		6
Introduction		7
1.	"We Follow the Road Backwards in Time"	9
2.	The Land of Days, Moons, and Eternity	37
3.	Life on the Mesas	51
4.	Hopi Religion	77
5.	"We Got Real Homesick"	83
6.	Hopi Arts and Artists	103
7.	The Hopi Tribe Today	123
Bibliography		127

Acknowledgments

Many people generously loaned photographs for this volume or helped identify people and places in the images. The authors wish to thank Jim Babbitt, Mark Bahti, Dorothy Busath, Andrew Christenson, Ryan S. Flahive with the Sharlot Hall Museum, Russell Hartman at California Academy of Sciences, William Havens, Rosalita Lalo, Harvey Leake, Rebecca Linville from the Arizona State Museum, Milland Lomakema Sr., Hopi Arts and Crafts—Silvercraft, Kim Messier and Pat Messier, Paul and Kathleen Nickens, Riley H. Polequaptewa, Hopi Silversmith, Beverly Rutter, Mary Sekaquaptewa, Mark Sublette, Edison and Karen Tootsie, and Richard Tritt, Cumberland County Historical Society. A special note of thanks goes to Laura O'Bagy for her careful reading of the manuscript and for her comments and corrections. A special thank-you also goes to the Mishongnoui Elderly Group.

Ramona Ami generously loaned a delightful Polacca Day School photo album from 1938–1939 that included narrative from Miss Winters, one of the day-school teachers. Ramona and others helped in identifying the students pictured. Mary Martha (Kaursgowva) Baumgartner shared her family photo albums. Other photograph collections were shared by Robert Arnold, Burton Cosgrove, Byron Hunter, and the late Mary May Bailey and Eleanor Means Hull.

Unless otherwise noted, all other photographs were taken by Milton Snow. This collection was generously donated to the Hopi Tribe by Walter E. Lamar.

INTRODUCTION

The Hopi people live on the arid mesas of northeastern Arizona on 2,500 square miles of tribal lands. Elevations on the mesas range from 4,700 to 7,800 feet, with an annual rainfall of only 10–12 inches. Twelve villages are located on or at the foot of three finger-like extensions known as Black Mesa. These settlements are hundreds of years old, although the Hopi people trace their existence back at least 2,000 years in the American Southwest. It is believed that their ancestors are the Hisatsinom, the ancient cliff-dwelling people who lived in the Four Corners region since prehistoric Basket Maker times.

In ancient times, according to Hopi tradition, the people lived inside the earth in the body of Mother Earth. The sacred place of emergence from the belly of Mother Earth is said to be located deep in the bottom of the Grand Canyon. Eventually they climbed a reed ladder and came into the world we know today. The people, identified by their clan groups, journeyed in a long migration to find a suitable place to settle, ultimately arriving at Black Mesa.

The earliest recorded outside contact with the Hopis was the 1540 Spanish expedition led by Francisco Vasquez de Coronado. Since most early visitors to Hopi country came from the east, the three projections of Black Mesa, going east to west, are now known as First Mesa, Second Mesa, and Third Mesa. The Hopi villages are located on these mesas, with another settlement, Moencopi, about 50 miles to the west. Many of the villages are ancient, with Oraibi, on Third Mesa, considered to be the oldest continuously inhabited settlement in North America, dating to 1150 AD.

The oldest Hopi villages are built with stone and adobe mud with rooms joined in a contiguous pueblo style. There are open plaza areas in each village, as well as kivas, which are the underground chambers that are the centers for religious ceremonies. Hopi people trace their lineage through clan membership that is based on descent through women; children belong to their mother's clan. Houses traditionally belong to the women, and when a man marries, he goes to live in his wife's home in her village. A man retains his clan lineage, but his children will be members of his wife's clan.

Among the Hopi, an often repeated comment is "corn is life." Corn is the most abundant crop produced by Hopi farmers; it is the food that has sustained the people for more than a millennium. Using dry farming techniques, Hopis grow many varieties of corn, and it is preserved and cooked in an amazing variety of dishes. Seasonal and religious activities are all related to planting, growing, and preserving corn. The complex religious ceremonies of the Hopi are focused on the end result of bringing rain for corn and other subsistence crops to grow. From the perfect ear of "mother corn" placed next to a Hopi infant, to the ritual grinding of corn in puberty and wedding rituals, to the sacred cornmeal that is blessed for use in ceremonies, corn figures prominently in all Hopi life passages and ceremonies.

Because of the harsh and arid landscape, Hopi religion centers on living in harmony and peace. *Katsinas* are a focus of Hopi belief; they are supernatural beings who are the spirits of the Hopi

people as well as of animals and insects. The katsinas will visit Hopi villages to perform ceremonies in the plazas and kivas between the month of December and July. The annual ceremonial cycle is directly tied to the seasons, with prayers directed to bringing clouds and rain to ensure adequate crops and the survival of the Hopi people.

Since the first contact with Spanish explorers in 1540 AD, the unique culture of the Hopi people has changed little and has consistently attracted outsiders who are fascinated by the Hopis and drawn to their land. These visitors brought goods from their culture that benefited the Hopi people, such as sheep, horses, fruit trees, and new crops. Conversely, outside contact also brought the introduction of ravaging disease, foreign education and government, and the imposition of alien religion and ideas. Amazingly, through centuries of contact, the Hopi people have sustained their cohesive culture. They have incorporated beneficial aspects of outside ideas and material goods while preserving their core culture and their rich arts and traditions.

The Hopi culture has the longest documented history of occupation in the Four Corners area of any Native American tribe in North America. The unique lifestyle of the Hopi people, their stark and beautiful mesa-top villages, their complex religion, and the allure of the Southwest landscape all combine to make the Hopi Mesas a timeless place of deep mystery and enduring attraction. As one visitor wrote as she traveled to the mesas, "the road stretched ahead of us to eternity," and we "follow the road backwards in time."

One

"We Follow the Road Backwards in Time"

The Hopi villages are located on three extensions of Black Mesa in northeastern Arizona. The older homes are located on top of the mesas and are built of stone and adobe mud, in a joined apartment style, with some buildings two to four stories high. Each village has open-area plazas where the katsina dances and other events take place. Additionally, there are kivas, the underground chambers where other ceremonies are conducted. The ceremonies that take place in the kivas are only open to Hopis. Newer towns have more recently been built below the mesa villages. Polacca is below First Mesa; a visitor center, hotel, and museum are all clustered on Second Mesa; and Kykotsmovi, or New Oraibi, is below Third Mesa and is the location of the Hopi government offices.

Small fields are located below the mesas where Hopi farmers grow corn and other crops. Since the fields are some distance from the villages, Hopis have developed exceptional long-distance running abilities. Moencopi, 50 miles west of Third Mesa, was originally a farming area, and men from Oraibi, Hotevilla, and Bacavi ran the 50 miles to their fields, sometimes running a round trip in a single day. The broad wash at Moencopi provided fertile fields, and by the 1870s, the area was permanently settled by people from Third Mesa.

Foot trails lead up to the mesas, and in addition to farmers traveling on foot to their fields, women walked the trails to get water from the springs below, to gather wood for cooking fires, and to collect wild plants, clay for their pottery, and other materials for their baskets. Roads were unpaved until just a few decades ago, and few Hopis had cars. Electricity and other utilities came late to Hopiland. However, some villages have chosen to remain traditional, such as Walpi on First Mesa, which has no running water or electricity. Conversely, homes below the mesas have all the modern conveniences. There are day schools in every village, and the high school is just east of First Mesa. A new health center below First Mesa features up-to-date services in a new building beautifully decorated by Hopi artists.

Hattie Cosgrove drew this map of the Hopi towns during her 1923 visit to Hopi country. Antelope Mesa, where the destroyed village of Awatovi is located, is to the east (right), with First, Second, and Third Mesa to the west (left). The villages of Hano (Tewa), Sichomovi, and Walpi are located on First Mesa (Polacca is below First Mesa); Shipaulovi, Mishongnovi, and Shungopavi are on Second Mesa; Oraibi, Bacavi, and Hotevilla are on Third Mesa, while Kykotsmovi, or New Oraibi, is below the mesa. The Hopi community of Moencopi is about 50 miles to the west near Tuba City. (Courtesy of Burton Cosgrove.)

The Hopi people have lived in northeastern Arizona for hundreds of years. Before they lived in this world, they lived below it in a vast underworld. In ancient times, they emerged into this world at a sacred place near the bottom of the Colorado River and began a search for the right place to settle. There are many sites with evidence of these migrations and prehistoric Hopi settlements, including the dramatic cliff dwelling sites of the Four Corners area and the ruins in Canyon de Chelly. (Above, author's collection; below, courtesy of Byron Hunter.)

There are three villages on First Mesa: Hano, Sichomovi, and Walpi at the western end. Polacca is below First Mesa to the east. In Hopi language, *Waala* is a gap and *ovi* is a place, so the name for Walpi village means "Place of the Gap." Tree-ring analyses of house beams from Walpi date the village to about 1700. (Both courtesy of Robert Arnold.)

A Hopi man rides a burro laden with water barrels up the dirt road leading to the top of First Mesa in November 1930. Ahead of him, another man drives a wagon up the mesa road. (Courtesy of Eleanor Means Hull.)

This 1923 view of Walpi from the far end of the mesa, west of the plaza, shows the *kiskya*, "archway." The Antelope Kiva is on the left side of the photograph and the Snake Kiva is to the right. (Courtesy of Burton Cosgrove.)

Stone steps lead up to the top of First Mesa on the southeast side of Walpi in 1923. (Courtesy of Burton Cosgrove.)

Hano, also known as Tewa, on First Mesa, was settled after the 1680 Pueblo Revolt by Tewa people from the Rio Grande country in New Mexico. Over the last two centuries, there have been intermarriages between the Hopis and Tewas, but to a remarkable extent, the Tewa people still retain much of their distinct language and culture. The road leading to First Mesa from the plains below runs along a row of stone houses in Hano. To the right, there is a stack of wood lining the edge of the mesa, which falls away to the plains far below, pictured here around 1970. (Courtesy of Byron Hunter.)

Kunaa, shown in 1927, was a Tewa woman who lived at Hano. Trachoma caused her to lose her eyesight, but she still was able to walk in the village and grind corn for her family. (Courtesy of Robert Arnold.)

Above, Tom Pavatea and his son "little Tom" stand in front of his trading post in Polacca in 1927. Tom Pavatea was a Tewa from Hano on First Mesa; his sister was the famous potter Nampeyo. Tom built the Polacca Trading Post at the base of First Mesa. Douglas Douma Sr. was his bookkeeper. Douma was the husband of Nellie Nampeyo, daughter of the potter Nampeyo. Displayed behind them (below) are many Hopi arts: coiled baskets from Second Mesa, gourd rattles, pottery from the Nampeyo family, mud head sculptures by Elizabeth White, and, at the top left, a c. 1930 sculpture of a head by Anglo artist Emry Kopta. (Above, courtesy of Eleanor Means Hull; below, Byron Hunter.)

The village of Shipaulovi on Second Mesa can be seen along the skyline. The pointed rooftops below are buildings at Toreva Day School.

The Dennis home was one of the first houses built below the village of Mishongnovi. (Courtesy of Eleanor Means Hull.)

The sacred pillars of Corn Rock tower in the sky on the old road up to the villages of Mishongnovi and Shipaulovi on Second Mesa in 1923. It is said that the people of Mishongnovi are responsible for protecting the sanctity of Corn Rock. (Courtesy of Burton Cosgrove.)

The mesa-top village of Mishongnovi can be seen just below the horizon from the neighboring Second Mesa village of Shipaulovi on October 1, 1944.

This view of the plaza at Mishongnovi was taken from a rooftop in 1923. A man on horseback is entering the plaza. (Courtesy of Burton Cosgrove.)

Both of the Second Mesa villages—Mishongnovi and Shipaulovi—can be seen on the tops of the mesa in this 1923 photograph taken from the north. (Courtesy of Burton Cosgrove.)

The south stairway to Shipaulovi on Second Mesa provided access to villagers when they walked to the valley below to work the fields. On the left side of the stone steps, a ladder extends from a kiva. (Courtesy of Burton Cosgrove.)

The ladder poles on the left indicate the presence of a kiva in the village of Mishongnovi.

Owen and Tolitha Munkewa lived at Mishongnovi on Second Mesa. This photograph of the couple wearing their finest ceremonial clothing was taken on September 30, 1944.

These stone houses are just below the old village of Mishongnovi, pictured in March 1944. The Second Mesa village of Shungopavi is located on the distant skyline.

Wood had to be gathered in the plains below the mesa and carried up the trail to homes and kivas on the mesa tops.

Traditional black-and-white striped blankets hang in front of a house facing the plaza in Shipaulovi in 1923 (above). Among the Hopis, men were the weavers, and blankets and garments were woven from cotton that was grown in the fields. (Both courtesy of Burton Cosgrove.)

This stone house is just below the old village of Shipaulovi.

The old trading post at Second Mesa is to the left. The village of Shipaulovi is at the top of the mesa in this 1930 photograph. The trading post at Second Mesa was located in the area between Shipaulovi and Mishongnovi. The stone building still stands, but it is now vacant and has not been used as a store for many years. (Courtesy of Eleanor Means Hull.)

A Second Mesa couple poses with their child just below the mesa top.

Hale Sekukaku operated the Second Mesa store in the 1940s. It was located below the mesa near Toreva. Note the posters on the wall promoting war bonds in this February 1944 photograph.

The village of Shungopavi is located on Second Mesa but on another prong of the mesa southwest of Shipaulovi and Mishongnovi. The name Shungopavi means the "Place by the Spring Where the Tall Reeds Grow."

Shungopavi is one of the oldest Hopi villages, with the earliest sites dating back to 1250 AD. By the 1400s, the second village was located below the mesa top. This was also near the site of the Franciscan mission of San Bartolome. Shungopavi was moved to the present mesa top site after the 1680 Pueblo Revolt.

Several Shungopavi men roll a log into place to repair a kiva roof in March 1944.

Children are playing in front of the Snow Clan house in Shungopavi in March 1944. Laundry hangs from a second-story roof; the second-story home to the left is gone now.

Stones line the sides of a spring just below the back road leading up to Second Mesa in May 1969. In earlier times, women walked down the trails to fill water pots every day, carrying them back up the steep trails to their mesa-top homes. (Courtesy of Byron Hunter.)

Carrying water was a heavy chore for Hopi women. Sometimes water could be caught in natural rock basins during the rainy season, but most domestic water had to be hauled from the springs that were located below the mesas. Hopi women used pottery jars to carry water to their homes. This Hotevilla woman is using a flat-sided pot with leather straps to transport her heavy burden. (Courtesy of Paul and Kathleen Nickens.)

Springs flow out of the sides of the mesa below Hotevilla on Third Mesa. Small terraced kitchen gardens trailing down the hillside provide greens and other special foods that are cultivated by women for their families.

Oraibi is the oldest continuously inhabited community in North America, dating at least to 1150 AD. At one time, it was the largest of the Hopi villages, but after the arrival of Anglo missionaries and teachers, a conflict arose between clans who wished to keep to a traditional way of life and clans who chose to send their children to the new schools. In 1906, those who had become Christians or were following Anglo ways were ordered to leave Oraibi. Over the years, the villages of Hotevilla, Bacavi, and Kykotsmovi (New Oraibi) were settled by people leaving Oraibi. (Courtesy of Burton Cosgrove.)

In this 1923 view of a vacant area of Oraibi, the walls of an unused kiva have collapsed, exposing a carved viga or roof beam that came from an abandoned Spanish mission church. Houses were boarded shut after 1906 when people left Oraibi. Even the kivas, the ceremonial centers, were unused. Seventeen years after the split, the Oraibi houses are abandoned, windows and doors boarded up. Today these buildings have collapsed and the rows of pueblo homes appear as low mounds. (Both courtesy of Burton Cosgrove.)

Windows and doors in the abandoned homes in Oraibi have mostly been boarded over.

In 1893, Mennonite missionaries Heinrich and Martha Voth came to Oraibi and built an imposing church at the southern point of Third Mesa. The church was hit by lightning several times, and many Hopis came to regard the place as bewitched and would not go near it. A few years later, Martha Voth died in childbirth. Heinrich buried his wife below the mesa and left Hopiland. Today the skeletal walls of the church and the bell tower can still be seen along the skyline of the mesa, shown here in 1927. (Courtesy of Robert Arnold.)

Kykotsmovi, or New Oraibi, was settled after the 1906 split, when people began leaving Oraibi, the old village on the mesa. The name means "Place of the Hills of Ruins." Today Kykotsmovi is the headquarters for the Hopi Tribal government. The complex of buildings of Oraibi High School, with dormitories, teachers' quarters, and the classroom building, is also located in Kykotsmovi. This 1944 view is looking south.

The trading post at Kykotsmovi was built by Frederick Volz, who sold it to J. L. Hubbell about 1914. Hubbell's sons, Roman and Lorenzo, operated the store until the late 1940s, when it was sold to the Babbitt family in Flagstaff, Arizona. The Babbitts remodeled the store and operated it until 1991, when it was sold to the people of Kykotsmovi village. The store is still in use today. In this 1948 photograph, store employees Sankey George (left) and Horace Kwani (right) help customers.

This 1930s photograph shows Hopi children posing for the camera as their father pumps gasoline into his car at the Kykotsmovi store below Third Mesa. (Courtesy of Mary Baumgartner.)

Moencopi, the "Place of the Flowing Stream," is located 50 miles west of Third Mesa, adjacent to the town of Tuba City, Arizona. In earlier times, Hopi farmers ran from their homes on the mesa to the Moencopi area, where the broad, arable wash provided fertile fields for growing corn, beans, and other Hopi crops.

This home in Upper Moencopi, shown in April 1944, belonged to Sam and Mardell Shingoitewa.

35

These Hopi dwellings at Moencopi show the stone construction of the homes. In early times, the dwellings were often two or three stories high and occasionally the walls were plastered. (Both author's collection.)

Two

The Land of Days, Moons, and Eternity

The starkly beautiful Hopi Mesas have always attracted tourists and outsiders. Since early contact, artists have been unable to resist the unique colors of the landscape, the strong and enduring features of the Hopi people, and the magical beauty of their ancient homes and customs. Maynard Dixon, the masterful painter of the Southwest landscape, was not immune to the lure of Hopiland. Writer Donald Hagerty noted that Dixon's stay on the Hopi Reservation became "an intense spiritual experience," and he had a lifelong "mystical attachment to the Hopi and their country." In an expression of the timelessness of the Hopi Mesas, Dixon wrote that time in the "ancient Province of Tusayan . . . is made only of days, moons and eternity."

Artists came to the Hopi Mesas and created some of their strongest work, which was inspired by the Hopi. The ancient ruins and villages were also an irresistible attraction for archaeologists, and eastern museums sponsored highly funded expeditions to excavate and document the early Hopi sites. Politicians such as then ex-president Theodore Roosevelt visited the mesas to tour and view a katsina ceremony; movie stars and tourists all made detours to visit the out-of-the-way villages. Writers and photographers also documented their visits to Hopiland.

While many visitors held deep appreciation for the ancient culture of the Hopi people, the U.S. government sent agents and teachers charged with working toward assimilation of the Hopi into the dominant culture. Beginning with the first Spanish expedition in 1540 AD, priests and missionaries attempted to force or lure the Hopis away from their traditional religion. The Mormon explorer Jacob Hamblin traveled to Hopiland in 1858 with a group of missionaries; Mennonites, Baptists, and Presbyterians arrived by the end of the century, all with the goal of converting the Hopis to Christianity. Through the last decades, thousands of visitors have descended on the Hopi mesas with intentions to change or convert, to document, to be entertained, to serve, or to exploit. The lure of the Hopi Mesas will always enchant outsiders.

The Hopi villages with their ancient stone houses and colorful katsina ceremonies have attracted tourists for more than 100 years. In 1927, Carey Melville, a Massachusetts college professor, and his wife and children made the long journey, over two-track dirt roads and through sandy or flooded washes, to visit the Hopi Mesas. To this eastern, urban family, the visit to Hopiland was as exotic a trip as visiting museums in Paris or ruins in Greece. (Courtesy of Robert Arnold.)

Burton and Hattie Cosgrove visited Awatovi on Antelope Mesa and walked across the ruins of the mission church of San Bernardo de Aguatubi in 1923. The Cosgroves returned as part of Harvard University's legendary Peabody Museum Expedition to excavate the abandoned Hopi village. The Cosgroves followed the steps of early archaeologists Jesse Walter Fewkes and Frederick W. Hodge, who both worked at First Mesa in 1895. Harvard's Awatovi expedition began in 1935 and lasted until 1939. Stories of the camp and the colorful people who worked there, the parties, a wedding, and sand dune skiing are still highlights of early southwestern archaeological legend. (Both courtesy of Burton Cosgrove.)

Harvard archaeologist A. V. Kidder visited the Hopi towns with Hattie and Burton Cosgrove in 1923. Here he is seen talking with a Hopi woman in the doorway of her home in Hotevilla. An early director of the Peabody Museum at Harvard University, Kidder was known as the "Father of Southwestern Archaeology."

Maynard Dixon (1875–1946) has been called "The Painter of the Southwest." He made many visits to the Hopi Mesas, sometimes staying for weeks and months at a time, sketching and painting every day. Dixon had a lifelong attachment to the Hopis and the mesa country; he wrote that the Hopi people were wonderful, and he found the landscape timeless and magical with "the long blue shadows" and "the sky where there is no time." The sketches of the Hopi man in profile and the Hopi woman holding a basket were both made during a five-month stay at First Mesa in 1923. Dixon returned to Hopiland many times; for the great Southwestern artist the place had an enduring influence. (Both courtesy of Mark Sublette, Medicine Man Gallery, Tucson, Santa Fe.)

After hearing from artist Louis Akin of his time spent with the Hopi Indians of northeastern Arizona, Kate T. Cory left her home in New York and traveled west in 1905 to visit the Hopi Mesas. Cory had purchased a round-trip train ticket but never did use the return portion after she arrived in Hopiland. Instead, she rented a house from a Hopi friend and lived in Oraibi in a tiny stone house on a top level of the pueblo reached by stone steps and ladders and later in Walpi village. Cory remained on the mesas for seven years. She later recalled that many nights she was awakened by the tread of moccasined footsteps on the roof above her pueblo house and heard the announcements of the Hopi crier or the singing of *Talavaykatsina*, the morning katsina who appears at the time of the winter ceremonies. The paintings and photographs from her time living with the Hopi people form an invaluable historic record of those early years. (Both courtesy of the Sharlot Hall Museum.)

Artist R. Brownell McGrew (1916–1994) visited Hopi country many times and painted dramatic portraits of the Hopi people. McGrew made many sketches of Hopi scenes during several trips to Shungopavi to visit his friends Jane and Charles Lomakema, and he later painted portraits of Jane and her children. This enchanting painting is of Emma Lomakema with her hair done in the beautiful squash blossom or butterfly whorls. (Both courtesy of Jill McGrew Bielenberg.)

Charles and Jane Lomakema's son Stanford was hired by Walt Disney producers to star in the 1967 movie *The Boy and the Eagle*. Stanford played a Hopi boy who befriends an eagle who helps him learn to survive in the forbidding high desert country surrounding the Hopi mesas. At the dramatic ending of the movie, the boy is driven to jump from the edge of the high mesa, but before he hits the ground, he turns into an eagle, soaring high into the clouds with his winged friend. As the pair of eagles flies across the vast landscape, a glimpse of turquoise shows the blue stone necklace that had been worn by the Hopi boy. Brownell McGrew visited the Lomakema family in Shungopavi and later painted this portrait of Stanford. (Courtesy of Jill McGrew Bielenberg.)

Theodore Roosevelt went on a hunting trip to Arizona's Buckskin Mountains in the summer of 1913. George Babbitt of the Flagstaff, Arizona, family outfitted the group. Lorenzo Hubbell, the well-known trader from Ganado, Arizona, made arrangements for the party to travel to Walpi to observe the Hopi Snake Dance. Roosevelt traveled in secrecy and slept in a tent to avoid notice. He wore his unpretentious camping clothes to the mesa and sat against a house wall in the plaza to watch the ceremony. The large man standing in the back row, and holding a hat in his right hand, is Arizona governor W. P. Hunt. Hunt's left hand rests against the right arm of Theodore Roosevelt. (Courtesy of Dorothy Busath.)

After the Mormon missionary Jacob Hamblin visited the Hopi mesas in 1858, outsiders began arriving, first U.S. soldiers and government agents and then the missionaries. Heinrich Voth, a Mennonite missionary, arrived at Oraibi with his wife, Martha, in 1893 and began to build a church at the edge of the mesa. His converts were few, and he became increasingly interested in collecting and documenting Hopi life and religion. After his church was struck by lightning the third time and his wife died in childbirth, he gave up his missionary work and left the mesas in 1902. (Courtesy of Byron Hunter.)

Abigail Johnson's lifelong dream was to be a missionary (the Hopis called her a "Mission Mary") and bring the message of Christianity to the Hopi Indians. She began her mission service in Polacca in 1901 and spent the next 36 years preaching "the Jesus Way." She became fluent in the Hopi language and translated many songs and Bible stories. Johnson loved the Hopi people but was uncompromising in her beliefs. She said there were only two kinds of people in the world, "believers in God and believers in Satan." She was a part of the life of the people, but she had no tolerance for Hopi religion. (Courtesy of Eleanor Means Hull.)

Abigail Johnson worked at First Mesa, where she was employed by the Woman's American Home Mission Society. She left for a time when she contracted tuberculosis, and after her return, she lived at Sunlight Mission below Second Mesa, here in 1913. (Courtesy of Eleanor Means Hull.)

Bertha Kirschke (left) and Ethel Ryan were Baptist missionaries at First Mesa during the 1920s and 1930s. The First Mesa Baptist Church on the next page is to the left, and the building to the right was the home of the missionaries. (Both courtesy of Eleanor Means Hull.)

This receipt from Tom Pavatea's Polacca Trading Post dated June 23, 1927, shows items purchased by the Baptist missionaries Ethel Ryan and Dorothy Humes, who lived in Polacca. In addition to their food purchases, it is interesting to note that they bought a woven plaque for $1 and "4 small pieces pottery" for 40¢, just 10¢ apiece. (Courtesy of Robert Arnold.)

46

Tootsie "Tutsi" and his wife, Hattie, were early converts to the First Mesa Baptist Church. His name was later taken as the family surname and changed to Tootsie. Tutsi and Hattie lived in Walpi on top of First Mesa (above), where he was a priest in the Snake Dance Ceremony, but they were forced to leave the village when they became Christians. They built their new house below the mesa at the western edge of Polacca in a place known as Palatksa, meaning "Red Clay." Tutsi was a farmer and a sheepherder, as well as a famed runner. He would run to Winslow, Arizona, and back in one day to carry messages, a distance of more than 70 miles each way, returning late in the night, 1935. (Courtesy of Robert Arnold.)

Mary Schirmer was the first missionary at Hotevilla. She lived in a stone house at the edge of the Third Mesa village. Her house later was used for Sunday school meetings for the Mennonite church. Over the years, she took in and raised five Hopi children; in this photograph, she is holding her foster daughter Mary, born in August 1939. Mary was born a twin, but because the girls' mother died in childbirth and there was no one in the family at that time to raise the twin daughters, Mary Schirmer took in the infants. One of the twins only lived three months, but Mary, pictured here at six months on a chair cushioned with a patchwork quilt (below), lived with her foster mother into her adult years. (Both courtesy of Mary Baumgartner.)

Daniel Schirmer was orphaned after his parents died in an epidemic. He was one of the Hopi children raised by Mary Schirmer, the Mennonite missionary at Hotevilla (at that time, it was illegal to adopt a Native American child, but Schirmer cared for Daniel as a mother for the rest of his life). Daniel later went to a Mennonite school in Kansas, where he learned German, and worked for a time in the mission field in Montana before returning to Hopi. Here Daniel is playing a portable organ in the plaza at Hotevilla. (Courtesy of Mary Baumgartner.)

This is a gathering of the women and children who attended Mary Schirmer's sewing classes as well as the Sunday school meetings. (Courtesy of Mary Baumgartner.)

Mary Schirmer held sewing classes for the Hotevilla women. Quilting and sewing were techniques used by the missionaries to attract people to the churches. While the women were sewing, the missionary would read Bible stories and talk about the church. There were few converts, but the women enjoyed the sewing and made many useful quilts and dresses and other articles of clothing. (Both courtesy of Mary Baumgartner.)

Three

LIFE ON THE MESAS

Hopis have farmed the sandy, arid soil below the mesas for hundreds of years. Traditional use of the small farming plots is linked to membership in certain clans and villages. Farmers plant several types of white, blue, red, yellow, and speckled corn, varieties that have adapted to the sparse rainfall. The plants are stunted, but the roots are exceptionally long and have been selected to reach every drop of moisture in the soil. After scientific testing, Hopi corn has been found to have higher food value than other varieties of corn. Many aspects of the annual ceremonial calendar relate to planting and harvesting corn, and corn grinding is a social as well as ceremonial activity at different times of the year.

Hopi farmers raise up to 14 varieties of beans. Tepary beans have been grown in the Southwest for centuries, while other beans were introduced. Wheat flour was introduced by the Spanish, and today it is used in Hopi Fry Bread, called *wequivi* or *wigaviki* in Hopi. Chilies are grown in Hopi fields; they are often seen today, as well as in vintage photographs, hanging from the eaves of a roof, drying in the sun. Wild greens are gathered mostly in the valleys and used fresh or dried. Ash from the four-winged saltbush is very rich in minerals and is used in certain foods. Also gathered is fruit from the yucca, prickly pear pads, wolfberries, and *suvipsi*, "squaw bush berries." *Hohoysi* leaves are steeped in water to make tea, and other wild plants are gathered for flavoring and also for ceremonial use. The root of the yucca is collected and used for hair washing, a part of many Hopi ceremonies, and the yucca leaves are used for making baskets.

In addition to farming and gathering wild plants, Hopis raise sheep and cattle; livestock is generally the property of the men. Fruit trees were introduced by the Spanish, and later, with roads and schools, trading posts, and government agencies, more material goods came into use.

Hopis are dry farmers, using only the sparse rainfall to nurture their crops. Fields are not plowed, and crops are planted in small groupings. Owen Lomahoitewa (below) uses a traditional digging stick to plant an early crop of corn in April 1944. His field is just below Mishongnovi near Corn Rock. Just a few kernels at a time will be scraped off of the corncob and planted in small groupings.

These small fields are partitioned with dirt edgings to catch and hold any rainfall. Windbreaks of sticks, bushes, and even old tin cans protect the young plants, trap snow and moisture, and function as erosion controls.

In ancient times, the Hopis had no horses or burros, and in order to reach their fields located far away in the valleys below the mesas, Hopi men became legendary long-distance runners. Running is also a part of many religious ceremonies. The artist Kate Cory recalled that when she went to Hopiland in 1905, it took her two days with an overnight camp in the desert to reach Oraibi. A Hopi runner at Canyon Diablo Trading Post left the same morning as Kate. He ran barefoot with a pack slung over his back, and he arrived back at his village at noon. Other early accounts tell of government officials at Third Mesa paying a Hopi runner $1 to take a message to officials at Keams Canyon, knowing there would be a reply back by nightfall. Burton Cosgrove took photographs of racers at an event on First Mesa in 1923. Artist Emry Kopta is seated on the stone wall at left. He lived for a time at First Mesa and sculpted busts of many Hopi people. (Both courtesy of Burton Cosgrove.)

Louis Tewanima was born in 1879 in Shungopavi on Second Mesa. Always a runner, as a boy, he would run to Winslow just to watch the trains and then run back to Second Mesa at the end of the day. As a Hopi traditionalist, he was arrested and taken to Fort Wingate in New Mexico, charged as a prisoner of war. In 1906, he was sent to Carlisle Indian School in Pennsylvania to learn a trade and "the ways of civilized life." At Carlisle, he excelled as a student and earned a reputation as a long-distance runner. In 1908, Tewanima ran in the U.S. Olympics in London, and in 1912, he won a silver medal at the Olympic Games in Stockholm for the 10,000-meter race. His Olympic performance set a record that remained unbroken for the next 52 years, until it was finally bested by another Native American runner. Although Louis Tewanima died in 1969, an annual footrace is held in his honor every Labor Day on Second Mesa. (Courtesy of Cumberland County Historical Society.)

After the Spanish introduced fruit trees, Hopis harvested crops of peaches, apples, and apricots. Early photographs show rocks and rooftops spread with peach halves drying in the sun. Apples were buried layer by layer in pits filled with clean sand where they were preserved through the winter. Because they are an introduced plant, the fruit trees need careful nurturing, including pruning and watering.

The Spanish introduced sheep after their arrival at Hopiland in 1540. The small, hardy animals were a reliable source of food, and Hopi men spun the wool and wove it into robes and garments. Every night, the herds of sheep were driven up to the stone corrals just below the top of the mesa for protection from predators. (Courtesy of Robert Arnold.)

Hopi men herd sheep in the fields below the mesa. Mutton is used in many dishes, and wool is spun and woven for many special garments.

Some Hopi families raise cattle on the ranch land below the mesas. Cattle are being loaded into a truck that will haul them to the auction.

Until well into the 20th century, there were no paved roads and very few automobiles in Hopi country. Some people owned a horse and wagon, but burros provided most transportation. The animals roamed freely through the villages but were penned in at night as protection from coyotes and other predators. This burro corral is at the edge of the mesa below Sichomovi on First Mesa. Walpi village is in the background in 1923. (Courtesy of Burton Cosgrove.)

Brownell McGrew sketched a burro on a visit to Hopiland in 1969. (Courtesy of Jill McGrew Bielenburg.)

Lomankeoma was severely crippled as a young man; consequently, he always rode a burro to get around. He was a Baptist convert and attended church faithfully. It was said that if he was ever too ill to attend church, his burro was known to go to the church alone and stand outside of the building until the meeting was over. He worked as a missionary to the Navajos and earned a salary of $5 a month for his work. (Courtesy of Robert Arnold.)

Hopi children often hopped on the back of a wandering burro. Since the animals did not wear bridles, they were guided by tapping the animal on the side of its neck with a stick. These boys are riding a burro during recess outside of Oraibi High School at Kykotsmovi, below Third Mesa, in March 1944.

Hongavi was the *kikmongwi*, "chief," of Sichomovi, the middle village on First Mesa. He is carrying a load of corn on his burro from his fields to his house in Polacca in 1927. (Courtesy of Robert Arnold.)

All the wood for cooking and heating had to be gathered and carried up the steep, rocky trails to the mesa tops. With his load of *suwvi*, "four-wing salt bush," this Hopi man in Walpi village in 1927 is likely carrying a load of wood for use in a kiva. Logs of cut juniper and pinon were used in homes for heating and cooking. (Courtesy of Robert Arnold.)

Edwin Kaywayumptewa drove a mail truck on the Kayenta route around 1935. (Courtesy of Mary May Bailey.)

Students at the day schools often had 4-H projects, for which they raised animals and learned how to care for and feed the animals. Richard Koopee showed off his 4-H goat at Achievement Day at Keams Canyon on April 28, 1956. (Courtesy of Ramona Ami.)

Chloris Augah was 17 years old in this 1927 photograph taken by Carey Melville. She was a Tewa from Hano and was a member of the Spider Clan. Chloris was also a skilled potter, and her work has been featured in several books on Hopi pottery. Dried or jerked strips of meat hang on the wire behind Chloris. Strips of meat can often be seen outside of houses hanging to dry in the sun. Slices of pumpkin, strings of bean pods, and red chilies also hang from roof beams. (Courtesy of Robert Arnold.)

The second photograph of Chloris Augah was taken in 1935 on her wedding day. Chloris (left) is wearing a traditional Hopi dress with a flowered shawl and moccasins with white deerskin wrappings. Her mother-in-law, Helen Choyou, "washed her hair," a reference to a ritual hair washing that is a part of the marriage ceremony. As a sign of her newly married status, Chloris's hair is divided into side plaits and twisted and tied with black woolen yarn, the "married woman's hairdo." (Courtesy of Robert Arnold.)

Two young mothers from Tewa Village on First Mesa show off their contented babies, each wrapped securely in a *taapu*, "cradleboard," in April 1944. Hopi men made cradleboards with pieces of split, bent wood, shown at the right. In the older style, Hopi women wove cradleboards with wicker or rabbit bush, shown at left. Some women also weave toy cradleboards, called *tapuya* in Hopi, that are used for dolls or katsina doll carvings.

Kanard Vincent, the young son of Waldine Tewawuna, sits at the foot of a ladder outside of his family's home in Shungopovi in March 1944.

Erma Tawyesva from Sichomovi on First Mesa was born during a smallpox epidemic; fortunately, she survived the terrible illness. Erma later married Luke Tawyesva, and they had nine children. In this 1927 photograph, Erma is holding one of her children who is securely wrapped in a cradleboard. (Courtesy of Robert Arnold.)

Life was hard on the mesas, and like all people of their time, the Hopis were victims of many diseases for which there were no effective treatments. Wilfred and Ethel Muchvo lost 11 children to tuberculosis. Miraculously, their 12th child, Vivian, survived and eventually had her own family. Wilfred was a farmer and katsina carver; Ethel was a potter and taught those skills to her daughter, seen here in 1935. (Courtesy of Robert Arnold.)

According to the caption written on this photograph by Carey Melville during his 1927 visit to Hopiland, "Wapya" is thought to be a Paiute who was given to a Hopi family; he was "traded when a baby at Corn Rock." During hard times of drought, crop failures, and epidemics, neighboring Piutes and Navajos sometimes brought a child to a Hopi family who would take him in and raise him, giving him a chance to grow to adulthood. One Hopi man recalled that as a boy he had an uncle, a Navajo man, who was taken in as a child and raised both as a member of the family and as a Hopi. (Courtesy of Robert Arnold.)

"UU wy a" was a Tewa bone doctor, called *tuuhikya* in Hopi, a healer who lived at the Water Clan house on First Mesa. He is standing in the plaza in front of a kiva in Hano in 1927. At Hopi, bone doctors heal joint and muscle problems, including sprains and broken bones. Some very powerful bone doctors are considered to have healed more serious, even life-threatening, ailments. (Courtesy of Robert Arnold.)

Jane Kewenvoyouma poses with her baby daughter in front of her house in Shungopavi in June 1944.

This photograph of Martha Sewuyumptewa and her daughter was taken at Mishongnovi on February 16, 1944.

Corn is prepared in many ways: it is eaten fresh or dried and ground for use in a multitude of dishes. Corn husks are used to wrap cornmeal tamales, as well as the sweet blue corn bundles, called *somiviki* in Hopi, that are wrapped in corn husks and boiled. Even corn smut, a fungus that grows on corn, is gathered and used in a fried dish called *nanha*. Here a Hopi woman takes a corn pudding out of a pit oven where it has baked overnight in 1923. (Courtesy of Burton Cosgrove.)

Over the centuries, the Hopis have learned many ways of preserving the bounty of the land and fields. Corn on the cob is dried or roasted fresh and then dried. Corn dried on the cob can be stored for later use during the cold winter months. Mardell Shingoitewa uses a second ear of corn to rub off the dried corn kernels in January 1944. The corn is then cooked or ground for a cornmeal that is used in a variety of Hopi dishes. The basket on Mardell's lap, as well as the one on the floor, is a sifter basket, most often used for holding corn and other food. The large plaque on the shelf to the left is made using a coiling technique.

Hopis grow many varieties of corn with colors ranging from white to blue, red, yellow, and speckled. If the corn is dried on the cob, it can be stored for many seasons. This Oraibi woman is using a wide sifter basket to gather her corn. She is wearing a traditional black dress, called a *manta* in Hopi, and her hair is wrapped in two side plaits, the "married woman's hairstyle." (Courtesy of Paul and Kathleen Nickens.)

Blanch Tewanima of Shungopavi was the wife of Louis, the famous Hopi runner who won a silver medal in the 1912 Olympics. In January 1944, she is making *piiki*, "paper-thin bread made from a blue corn meal batter." Blanch would dip her fingers into the bowl on the floor to her right and smear a thin layer of the batter on a stone griddle. A fire under the stone griddle heats it to the right temperature, and the batter instantly cooks and crisps. The thin layer is quickly folded in half and rolled into a tube. To her right is a flat sifter tray holding rolls of piiki, as well as flat sheets of piiki that will be reheated and rolled or folded.

69

Hopi homes traditionally have three stone bins for grinding corn from a coarse to fine texture. Corn grinding is associated with a girl's Coming of Age Ceremony as well as a social time. Hopi women today have hand or electric grinders, and there are commercial mills in some villages where larger quantities of corn can be taken for grinding. Nevertheless, women still hand-grind corn for weddings and other ceremonies. (Courtesy of Paul and Kathleen Nickens.)

A Hopi maiden grinds corn as part of her Coming of Age Ceremony. Each of the stone bins is used to grind the kernels to a particular fineness. As the corn is ground, it is scooped into pottery bowls, and the twig whisk broom, made from grasses gathered below the mesas, is used to sweep up any stray bits of cornmeal. (Courtesy of Paul and Kathleen Nickens.)

Mardell Shingoitewa (left) and Cary ? grind corn for piiki in Mishongnovi Village in April 1944. Sifter baskets and a cooking pot hang on the wall above the women, and a coiled basket can be seen on the floor next to the bin.

A traditional Hopi meal and table setting on the floor usually consists of beans, piiki bread, outdoor-oven-baked yeast bread, and Hopi teas, such as *Sita* or *Hohoise*. The Hopi seldom partake of meat except on special occasions such as ceremonies, weddings, and baby namings. The April 1944 photograph shows Mardell Shingoitewa (center with coffee cup) and her family and grandparents at a meal in their home at Mishongnovi on Second Mesa.

71

A traditional baking oven, which is still used today, is located at the edge of First Mesa. A fire is built inside on the floor of the oven. When the fire burns down and the oven is heated, the coals are swept out; loaves of bread are placed inside to bake and a cover is put over the opening. These breads are most often used for weddings and ceremonies. One Hopi woman explained that her bread oven could hold all the bread she could make from a 25-pound sack of Bluebird Flour. (Courtesy of Robert Arnold.)

In the village of Shungopavi, Belvera Nuvamsa (left) and Mary Anna Nuvakaku are grinding corn for the Coming of Age Ceremony, which involves grinding corn for four days. During the ceremonial period, the girls are not allowed to come in contact with the sun. Before the ceremony, the girl's hair is put up in the butterfly hair whorl style signifying a change in status from a child to an adult. After the ceremony is over, the girls are considered young women and are eligible for marriage.

Hulda Seckletstewa gives Eleanor Quyo a Hopi "married woman's hairdo" at Mishongnovi, Second Mesa, in March 1944. One Hopi woman recalled that in addition to wrapping her hair with black wool in the married woman's hairdo, older Hopi women used coal dust to cover any gray hairs in order to keep their hair a rich, raven's-wing black.

Running water, which was piped into the Toreva Day School at Second Mesa, was almost a luxury for the Hopi women, pictured here in 1944. They could carry their laundry to the school and use the heated water without carrying buckets from the springs and heating water over open fires. Laundry day still involved carrying bundles of clothes down the rocky trail and then up again to the top of the mesa. Before the laundry rooms were built at the schools and mission churches, women carried their clothes and washtubs to springs below the mesa, where they filled the tubs, heated water over a fire for washing and rinsing, and then spread the clean clothing over rocks and bushes to dry in the sun. It was a social time in fair weather but a miserable chore in the winter.

Ruth Takala and her mother Sehepmana are shown on a 1927 laundry day at Polacca. (Courtesy of Robert Arnold.)

Hopi men, such as this Oraibi weaver seen around 1900, have traditionally been the ones who spun and wove the fabrics that were used for clothing, blankets, and ceremonial garments. Hopi farmers raised cotton in prehistoric times, later spinning and weaving wool from sheep introduced by the Spanish in the 16th century. In modern times, Hopi men still weave robes and garments for weddings and ceremonies. (Courtesy of Paul and Kathleen Nickens.)

Many practical skills were taught at the Oraibi High School. These eighth-grade boys are weaving in the classroom on April 20, 1945.

Four

Hopi Religion

Ancient beliefs deeply permeate every aspect of daily life among the Hopi people. Katsinas are the spirits that appear in the dances held in the first part of the year. Sometimes they are referred to as the cloud people, as these beings bring rain and are believed to embody the spirits of those who have passed on. The yearly ceremonial cycle is complex and determines the times for planting and harvesting, initiations and thanksgivings, and the essential well-being of the people.

The Hopi people, their culture, and religion have always held a fascination for people around the world who have come to the Southwest to observe the extraordinary katsina ceremonies. Additionally, they shop for the beautiful and highly collectible Hopi arts, pottery, baskets, and katsina carvings, and walk through the stark and dramatic pueblo villages perched on the tops of the craggy mesas. Author Peter Nabokov called Hopiland the "Athens of the Indian world," and "America's Nepal." Since the time of the first early contact with outsiders, Hopiland has attracted adventurers and explorers, missionaries, writers, artists, actors, politicians, throngs of tourists, and people from every profession.

While outsiders have always been welcome to visit the Hopi Mesas, the Hopi people ask that tourists remember that the ancient stone pueblo buildings are their homes, that their ceremonies are religious rites, and that respectful behavior should always be observed by visitors. Some version of these signs can be seen at the entrances to villages on each mesa; certain katsina dances are generally closed to outsiders, and villages are sometimes closed to visitors because of special events. (Both courtesy of Byron Hunter.)

Artists and other visitors have long been captivated with Hopi ceremonies. Cameras, renderings, and recording devices are all prohibited in Hopiland, but the people and the mesas continue to fascinate and compel artists to compose their interpretations of Hopi life. (Courtesy of Barry Sapp.)

Visitors came from everywhere to view the Hopi dances. This postcard of a village scene shows spectators at a Snake Dance in Hotevilla. On the back of the postcard, the viewer wrote, "The seating arrangement in Mishongnovi on August 19, 1931 was not unsimilar to this. The bright colors of the store shawls, including from Checo Slavakia [sic], and the bright dresses of the Indian women, also gay blouses of the American spectators, made a fitting background for the occasion. Much silver and turquoise Navajo jewelry was worn by all. Indian men wore bright head sashes. The Navajo men and women wear colored velvet blouses. Mr. Ramon Hubbell, descendent of Lorenzo Hubbell an old time trading-post character, with large holdings on the Navajo Reservation, looked stunning in Stetson broad brim, purple velvet blouse, concho belt, bright variegated silk kerchief, riding trousers, tall brown leather (suede) moccasins. Talked with him in Oraibi." (Courtesy of Paul and Kathy Nickens.)

Taqui was a Hopi snake priest. He would have led or participated in all the observances associated with the sacred nine-day ceremony. He appears here in ceremonial attire with a large silver necklace around 1905. (Courtesy of Paul and Kathleen Nickens.)

These Hopi men participated in the Snake Dance at Mishongnovi. They are dressed with their finest jewelry, silver necklaces and bracelets, strings of turquoise, and silver concho belts around 1915. (Courtesy of Paul and Kathleen Nickens.)

8602 Mishouginon Snake Men, Toriva, the Day After the Ceremony, Arizona.

Dressed in her best clothing around 1900, this Hopi maiden was likely preparing for a ceremony. In addition to a traditional black dress or manta, she wears colorful shawls and a silver necklace. Her hair is dressed in the traditional hairstyle often called a butterfly whorl or a squash blossom, since it represents the flower of the squash plant; she also wears turquoise hair clips on each side of her head. (Courtesy of Paul and Kathleen Nickens.)

The Butterfly Dance is performed in late summer by the young people. During this social dance, girls wear the beautifully carved and painted headdresses that represent the colorful wings of a butterfly. (Courtesy of Paul and Kathleen Nickens.)

Waldo Mootzka was a Hopi artist whose paintings are in many museums and private collections. He created this image of the sacred Niman ceremony in the late 1930s. Niman, also known as the Home Dance, is a 16-day ceremony held in mid-summer when the katsinas depart for their spiritual home in the San Francisco Peaks. (Courtesy of the California Academy of Sciences, Ruth and Charles deY. Elkus Collection, catalog No. CAS 0370-1237.)

Five

"We Got Real Homesick"

Early education efforts among the Hopi people were not so much aimed at educating children as eradicating all vestiges of their Native American culture. The U.S. government had a policy of assimilation based on the assumption that removing children from their homes and sending them to distant boarding schools would instill beliefs and skills that would bring the students into contemporary Anglo society. Young children were forcibly taken from their homes—military troops made dawn raids in the villages and searched the houses to gather up the children—and sent to distant schools. At the boarding schools, their hair was cut off, they were dressed in military-type uniforms, and they were not allowed to speak their native language or practice their traditional religious ceremonies.

Hopi fathers who resisted the U.S. policy of their children being sent to the schools were arrested. Some men were taken in chains to Keams Canyon, where they were forced to build roads for the government. Helen Sekaquaptewa was one of the children whose father was taken to the Keams Canyon jail. Helen was only eight years old when the soldiers took her away to school. She did not see her parents again for two years, when she was allowed to go back to Third Mesa for a visit.

Fortunately, by the 1920s, attitudes in Washington changed when it became apparent that government efforts to eradicate Hopi culture and religion had failed. Furthermore, a growing number of people—teachers, politicians, and activists—campaigned to stop the assimilation policies and to build schools within the Hopi towns so children could be educated in their own communities. During the 1930s, the government began building schools in the Hopi villages so children could attend local schools. And rather than attempt to erase the traditional culture, teachers often used Hopi stories and images in teaching the students. Hopis place a high value on education, and today, with schools nearby where parents can visit and give input, most students graduate and many continue on to study for professional careers.

In 1895, a group of 19 traditional Hopi men were taken prisoner at gunpoint and sent to Alcatraz. Their crime was refusing to send their children to school. A California newspaper stated that they refused to live the "civilized ways of the white men." The men were held at Alcatraz for seven months before being returned to their homes.

Unlike many teachers in early Native American schools who sometimes worked to eradicate most traces of traditional native life, teachers at the Polacca Day School used art and images of daily life to teach reading, writing, English, geography, and mathematics. In this Polacca classroom in 1927, nearly all of the images and teaching tools come from Hopi culture. (Courtesy of Robert Arnold.)

Bertha Kirschke, shown here in 1927, was a Baptist missionary as well as a teacher at the Polacca Day School. Edison Tootsie, one of her pupils, remembered her as a wonderful, concerned teacher who helped with expenses so he could attend high school at the Albuquerque Indian School. Kirschke believed that he had much promise as a student and that he would be exposed to a more challenging curriculum there. (Courtesy of Robert Arnold.)

The Polacca Day School was located on a hill below First Mesa in the village of Polacca. Classroom emphasis was on Hopi life in relation to the outside world. English was emphasized in the classroom, and instruction included conversation, games, and dramatization. Course instruction and tests came through issues of *My Weekly Reader*. The beginners group constructed a miniature replica of Walpi village using clay, paints, and other materials. Bennie Lacapa is holding the sign (above) at the left, and Betty (Nahee) Navakuku is standing at the right side of the table. The students also drew a mural of "Hopi Fields in Spring." First-grader Zella (Douma) Kopyaquaptewa holds the pointer (below), and Virginia (Pavatea) Poola is to the left. (Both courtesy of Ramona Ami.)

The first-grade students built a model of a Mother Goose Village in a sandbox using clay, paints, and cardboard. In order to perfect their English skills, the children memorized Mother Goose rhymes and gave oral presentations. Standing around the sandbox table from left to right are unidentified student, Benson Seeni, Edmund Mutz, Frankie Tungovia, and Judith Poola. (Courtesy of Ramona Ami.)

The beginner students constructed the Valentine Post Office seen in this 1939 photograph. Seated from left to right are Wilson Huma, Murry Leslie, and unidentified. (Courtesy of Ramona Ami.)

Older students at the Polacca Day School participated in an agricultural course that involved raising two pigs for food. The students built a shed and pen for the pigs; they fed and cared for them through the school year and then butchered the animals. From left to right, Percy Pavatea, Herbert Poocha, Julius Nahsonhoya, Alexander Ami, Stetson Lomakema, Paul Sidney, and Benjamin Maha are feeding the pigs and cleaning the pen. The boys had a "Pig Club," and they all took turns working with the animals. (Courtesy of Ramona Ami.)

Students in each of the older classrooms formed committees, each having a job related to processing the pig. Those jobs included rendering the lard and making sausage and mince meat. Third-grade girls Dextra (Namingha) Quotskuyva, Lorna (Adams) Lomakema, and Ramona (Naha) Ami are stuffing the pork links for sausage. After the fat was rendered, the girls made hard and fat soap. Elaine (Seeyouma) Tewa, Ramona (Naha) Ami, and Edith Satala display their soap products. In addition to learning about the care, feeding, and by-products of the animals, the students wrote their own "Pig Book" in which they recorded their stories of raising the pigs. The culmination of the pig project was a pig dinner. (Both courtesy of Ramona Ami.)

Not to be outdone by the boys, the girls requested some hens for a "Chicken Project." With help from Mr. Sharp from the Phoenix Indian School, the students built a trench brooder and raised a flock of 140 chickens. As the chickens matured and reproduced, local Hopi women came to the school to purchase their own baby chickens. Ella (Lalo) Ami (right, posing with teacher Miss Summers) purchased 50 chicks. The jugs were frequently filled with warm water to keep the baby chickens warm. (Courtesy of Ramona Ami.)

Students from the Polacca Day School were taken on field trips to Winslow and Flagstaff, Arizona. In January 1939, Mr. Kaniatohe chaperoned a group of students on a trip to Winslow. Some of the students in the photograph are Florence Lahpo, Elaine Seeyouma, Beth Shupla, Paul Sidney, and Peray Pavatea. (Courtesy of Ramona Ami.)

Seen above from left to right, Harrison Pooyquaptewa, Emory Kinale, and Roderick Lomakema made wooden book covers and a magazine holder in their shop class. Teachers found that the favorite books among the Hopi students were stories that they and their friends had written about their lives and Hopi culture. Consequently, in the English classes, all of the grades were encouraged to make their own books with stories the students had written. Older boys at the Polacca Day School learned many woodworking skills in the school's shop class. Shown below, they are posing in front of the school library building with the pieces of furniture they had built, prior to taking the pieces to their homes. (Both courtesy of Ramona Ami.)

The Shungopavi Day School was located below Second Mesa. This photograph in which three students are just visible approaching the school in the center of the image is titled "View from Trail." The children walked the trail each day. The principal's house is on the left, and the large building at the right held classrooms. A basketball court was located in the flat area between the middle building and the BIA road. The school was demolished in the early 1960s.

Older children at the Shungopovi Day School are learning to make moccasins in March 1944.

Children at the Shungopovi Day School are watching workmen unload supplies from the truck in March 1944.

The Keams Canyon Boarding School served both the Hopi and Navajo people. During the 1940s, roads on the reservations were unpaved, and even though Hopi villages and Navajo homes were located only a few miles from the school, the students resided in the dormitory because of the amount of time it took to transport the children to school. Another reason for the dormitories was that few families had automobiles at that time. Consequently, the children spent the week at school and went home on weekends. These boys are building model airplanes during their spare time.

The boarding school system often hired local people to work different occupations within the school complex. By doing so, the government introduced new skills to the local population as well as having someone at the school who was known to the children. Vincent Polacca, a Tewa, was employed as a baker at the school on January 28, 1944.

At the Keams Canyon Boarding School, Hopi students were not only given traditional instruction but also were taught other skills that would be beneficial later in life. These girls are storing canned fruit and vegetables they had preserved for the school year on January 28, 1944. Boarding schools typically had full gardens in the summer months to supplement the food supplies for the entire school year.

Oraibi High School was located below Third Mesa toward the western edge of Hopiland. Most of the original buildings of the old high school are still in use today, although the school is now a day school for younger children, while older children attend the new Hopi High School just east of First Mesa.

Polingaysi Qoyawayma (Elizabeth Q. White, 1892–1990) grew up at Oraibi and attended the Anglo boarding schools. She was the first Hopi to return to teach in the Hopi schools. Here she is shown with a group of students at the Oraibi High School in March 1944. She later wrote the story of her life in *No Turning Back: A Hopi Indian Woman's Struggle to live in Two Worlds*.

Local children attended Oraibi High School each day, walking or riding to school. When the school first opened, the First Mesa students rode the bus every day. But with the rough roads and the long distance, sometimes it took all morning for the bus to reach the school at Third Mesa. Many times, they arrived in time for lunch, and then the students would have to turn around and start back home shortly afterward. Consequently, most students from First Mesa stayed in dormitories at the school and returned to their homes on the weekends. In the Hopi tradition, many of the boys from Second Mesa ran the foot trails to the high school. It was a 12-mile round-trip. After class, the students did homework, socialized, and prepared for the next school day.

Art and reading were important parts of the curriculum. Mr. Kennedy taught geography and also served as the advisor for the Student Council at Oraibi High School in 1944.

Mrs. Wallace taught home economics at Oraibi High School. Rebecca Nahoitewa (left), the school cook, observed the girls in sewing class. Some students are stitching garments on treadle sewing machines; others are piecing quilt blocks.

The girls in the home economics classes had each made their headbands and aprons in the sewing class.

Girls in Mrs. Wallace's home economics class observe as a teacher demonstrates proper methods for caring for an ill patient. The sheets and blankets folded over the chair on the left indicate that part of that instruction would have included how to change a bed when a sick patient was too ill to be moved.

Rebecca Nahoitewa, the cook at Oraibi High School, prepares meals for teachers and students.

Older students relax, above, after class at Oraibi High School. The students in the center are playing checkers. On the wall behind to the left is a mural painted by Charles Loloma, a Hopi artist and teacher at the high school. Below, also at Oraibi High School, shows a mural painted by Loloma of Hopi farmers plowing and tending to corn crops.

Barry Goldwater greatly admired the Hopi people, and he was a friend to them, making many visits to the mesa country over the years of his distinguished career. In June 1969, he attended the ceremonies of the eighth-grade graduating class of the Keams Canyon School (below). He greeted the graduating students and visited with Joan Hunter (left), wife of Byron Hunter, the trader at the Polacca Trading Post below First Mesa. (Both courtesy of Byron Hunter.)

Six

Hopi Arts and Artists

The Hopi are known for their beautiful artwork, which is in constant demand from shops, museums, and collectors. First Mesa women have been creating beautiful pottery for many generations. Today several Hopi men have learned the craft and are also known for their fine work. Women on Second Mesa weave sifter baskets and coiled plaques, while Third Mesa women craft flat wicker plaques.

Hopi men have always woven clothing, blankets, and ceremonial kilts and robes. In early times, these weaves were created from cotton fibers grown in Hopi fields. After the Spanish introduced sheep, wool was incorporated into Hopi textiles. Much of the weaving is done in the kivas, where kilts, blankets, and other garments are made for weddings and other ceremonial purposes. Hopi men also carve katsina dolls, and some are silversmiths.

For more than a century, Hopi artists have been invited to travel to museums and other sites to show and demonstrate their artwork. In the early years of the 20th century, the skilled potter Nampeyo was invited by travel entrepreneur Fred Harvey to spend summers at Hopi House at the south rim of the Grand Canyon demonstrating her beautiful pottery; other potters and artists were also featured there. In the years since, many Hopi potters, basket makers, katsina carvers, and artists have shown their work and provided demonstrations at museums from California to New York.

Florence Koinva and Spencer Kewenvoyouma stand in front of a display of Hopi arts. In front of Florence is a sifter basket filled with rolled piiki. Behind them, from top to bottom, are sifter baskets and a tall coiled basket, coiled and wicker plaques, and one hanging shallow bowl, then a row of hand-carved katsinas and sifter baskets below the katsinas.

Lloyd Taleswaima (left) and Hale Sekakuku show off a display of pottery and baskets.

After Tom Pavatea's store at the base of First Mesa, the Polacca Trading Post, burned in the early 1960s, it was rebuilt down on the highway and just a bit east of the original store site in 1969. It remains in operation today as a convenience store. Before people commonly had automobiles, the trading post served as a trading center where artists traded their work for food and other necessities without having to make a long journey to Winslow or Flagstaff. (Courtesy of Byron Hunter.)

Herman Sidney wraps pottery for shipping in this March 1969 view of the interior of the Polacca Trading Post. (Courtesy of Byron Hunter.)

Nampeyo was a master Tewa potter from Hano on First Mesa. She is credited with reviving a style of pottery that had fallen into disuse among Hopi potters, but it was rediscovered when archaeologists excavated the abandoned village of Sikyatki. Nampeyo used those ancient pottery designs as inspiration for her own artistic vision. Her brother was Tom Pavatea, who owned the trading post at Polacca, and much of Nampeyo's fine work was sold through his store. (Courtesy of Paul and Kathleen Nickens.)

Sellie, shown here in 1927, was a potter who lived at Polacca below First Mesa. The Gap is visible behind her along the skyline, and Sellie's stone house can be seen just above her below the Gap. Sellie was known as "Strong Woman" because after her husband died, she decided to move to Polacca, and she carried every rock and bucket of water and built the house herself. (Courtesy of Robert Arnold.)

Hattie Carl posed for her photograph in 1927 in traditional Hopi attire. She was one of the first Hopi potters to sign her work. Her husband, Edwin, took his sheep to Winslow to sell, and Hattie would go along with him. They camped near La Posada, the famed hotel along the Santa Fe Railroad tracks. Hattie sold her pottery to tourists who got off the train and, because so many asked for her name, she began signing her pottery with the hallmark that signified her Hopi name, Omacsi, meaning "Cloud Flower," 1927. (Above, courtesy of Robert Arnold; below, author's collection.)

Lucy was photographed in 1927 (above) by Carey Melville while she was building a pot in her First Mesa home. In 1933, Lucy and her husband, Lalo (left), were invited to attend the Chicago World's Fair, where Lucy demonstrated her pottery-making skills. (Above, courtesy of Robert Arnold; at left, Karen Tootsie and Rosalita Lalo.)

Laura Chapella Tomosie demonstrated and sold her pottery at the Holbrook stock show and county fair in 1938. She is pictured with a huge cylindrical vase, two smaller vases, a bowl with a straight rim, and a stew pot (the bowl with the flared rim). Laura dressed in her finest traditional clothing for the public demonstration. She was a member of the Bear Clan and lived at Hano on First Mesa. (Courtesy of Ramona Ami.)

Grace Chapella (1874–1980) was a renowned potter whose work is in many museum collections. She was from the Tewa village on First Mesa and was a member of the Bear Clan. She was married to the trader Tom Pavatea and later to John Makhewa; her sister was Laura Chapella Tomosie. Grace shows one of her large pots as she sits on a bench in front of her stone house in Polacca. (Courtesy of Bryon Hunter.)

Nellie Nampeyo (1896–1978), daughter of Nampeyo and Lesso, sold her magnificent bowl to the Polacca Trading Post in March 1969. Standing to the left is Greg Hunter, son of the Polacca trader Byron Hunter. (Courtesy of Byron Hunter.)

Marietta Poocha smooths and polishes her unfired pottery with water and a polishing stone while chatting with Ella Fritz in June 1968. (Courtesy of Byron Hunter.)

In 1968, Edith David smooths her unfired pottery before it will be painted and fired. (Courtesy of Byron Hunter.)

Caroline Talas shows two of her unfired, unpainted pots in December 1967. They must dry and harden before they can be fired. (Courtesy of Byron Hunter.)

Caroline Talas began preparations for firing her pottery early on a snowy January morning in 1968. First she built a fire, letting it burn down to coals. The unfired pots are placed near the fire to warm, and when the flames died down, she placed her pot upside down on the coals. Then the pot was covered with pieces of dried cow or sheep dung. When the dung burned away and the coals had cooled, Caroline uncovered her beautiful pot. (Both courtesy of Byron Hunter.)

Early katsina dolls, called *tihu* in Hopi, were carved from the dried root of a cottonwood tree and painted with natural pigments; today contemporary carvers mostly use acrylic paints. Tewaquaptewa, a carver from Oraibi, used natural pigments such as the minerals ground in the stone bowl sitting at his feet. (Courtesy of Paul and Kathleen Nickens.)

A Polacca man, Hongavi, shows his katsina carving in 1927. (Courtesy of Robert Arnold.)

113

Hundreds of katsina doll carvings line the shelves of the Polacca Trading Post in March 1969. (Courtesy of Byron Hunter.)

Edwin and Lucinda Choyou posed with the large katsina carvings at Polacca Trading Post in August 1967. (Courtesy of Byron Hunter.)

Huge drums are used in Hopi ceremonies. Earl Muncapa from First Mesa carved the sides for a drum from a hollowed section of a cottonwood tree as his grandson plays next to him in April 1970. (Courtesy of Byron Hunter.)

Florence Koinva (left) and Nellie Lomahaftewa (right) stand behind sifter baskets piled with blue piiki, while Spencer Kewenvoyouma (center left) and Viets Lomahaftewa present katsinas, pottery, and silver jewelry in 1944. Behind them is a display of coiled and wicker plaques. Traditional woven robes with geometric designs stitched along the borders hang above them.

Fred Kabotie, left, was born in the village of Shungopavi in 1900. He attended school in Santa Fe, New Mexico, where he gained recognition for his artistic talent. Travel entrepreneur Fred Harvey built the Watchtower at Desert View at the Grand Canyon in 1932, and Kabotie was hired to paint the interior murals. In 1937 he began teaching art at Oraibi High School; two years later his paintings were shown nationally at the Golden Gate Exposition in San Francisco. In 1941, Kabotie's art was featured at New York's Museum of Modern Art. After World War II, Kabotie worked with Hopi silversmiths. Fred Kabotie, an inspiration to generations of Hopi artists, died in 1986. (Courtesy of Kim and Pat Messier.)

Otis Polelonema (1902–1981) was a well known artist from Shungopavi on Second Mesa. He was educated at the Santa Fe Indian School and later was an artist with the WPA (Works Progress Administration). His painting of the Shalako dancers won a first prize at the 1969 Heard Museum Show. (Courtesy of Byron Hunter.)

HOPI BASKET MAKER
Performing Work of Skill and Beauty

Women from Third Mesa weave colorful wicker baskets and plaques. Some are sold to collectors, while others are made for ceremonial use. They are given as part of wedding and social dance paybacks. *Siwi*, "dune broom," and *sivaapi*, "rabbit brush," are used for the wicker plaques. (Courtesy of Paul and Kathleen Nickens.)

Abigail Kursgowva was born in Hotevilla on Third Mesa in 1915. She has been making beautiful wicker baskets all of her life.

Visitors to the Hopi country have long been captivated with the beautiful baskets created by Hopi women. In 1927, Maud Melville and her family purchased several remarkable coiled baskets that they had specially crated and shipped back to their home in Massachusetts. (Courtesy of Robert Arnold.)

The Basket Dance, *Lakon*, is the culmination of a ceremony conducted by Hopi women during the fall. This vintage postcard depicts a Basket Dance in the plaza at Walpi. (Courtesy of Paul and Kathleen Nickens.)

Jean Navenma (right) and her daughter Jennes work on coiled baskets in their Mishongnovi home on Second Mesa in April 1944. Jean's basket has a deer motif.

Pearl Nuvangyaoma was born in Shipaulovi in 1926; her Hopi name was Pretty Bluebird Girl. Her mother Alta was a member of the Sun Forehead Clan, and she taught Pearl, as well as her other daughters—Frieda, Mary Jane, Rita, and Patty—to make fine coiled and sifter baskets. All of the sisters were renowned basket makers who exhibited their work at national museum shows. Alta was also a quilter, and she and her daughters stitched quilts to keep their families warm during the winter. Pearl remembered walking down to the Sunlight Mission with her mother when the missionaries had quilting days, and they would sew together. Pearl's quilts are colorful and scrappy, she pieced them as she would make a basket, starting in the center and working outward, following the patterns in her head. Pearl is standing below Second Mesa; her house is a traditional stone house on the plaza. Pearl passed away in 2007 at the age of 81. (Author's collection.)

In the 1920s, there was no trading post in Shungopovi and it was a hardship to walk many miles to one of the stores in another village. In 1927, Nellie Quamalla decided that she would make a huge coiled basket, and with the money she could get from selling it, she would open a small store in the spare room of her house. She worked on the coiled basket for two years; when she finished it, the basket was as tall as she was. She sold the magnificent basket to trader Tom Pavatea at Polacca for $500, and with that money, she and her husband, Archie, established a small store in the village. The March 1944 interior shot above of Nellie's house shows many fine coiled plaques. Notice the two large square sifter baskets, one on the bed and another hanging to the left of the doorway. (Above, courtesy of Milton Snow; below, Robert Arnold.)

Douglas Douma Sr. worked as a bookkeeper for Tom Pavatea at the Polacca Trading Post. Here he stands on the loading dock of the store next to the huge basket made by Nellie Quamalla in 1929. (Courtesy of Robert Arnold.)

In *Hopi Silver*, Margaret Nickelson Wright wrote that sometime in the 1890s, a Zuni silversmith taught the craft to a Hopi named Sikyatala, the Hopi word meaning "Yellow Light," who in turn shared his skills with two Second Mesa men. One of those men, Tawahongniwa, had five sons who all became silversmiths. The fifth son was Washington (he was called "Wa sen to") Talayumptewa, who was a skilled silversmith until his death in 1963. Here he sits in front of his Shungopovi house polishing a silver bracelet on February 18, 1944.

In 1930, Dr. Harold S. Colton and his wife, Mary-Russell Ferrell Colton, began an annual Hopi Craftsman Exhibit at the Museum of Northern Arizona in Flagstaff. Mary-Russell Colton encouraged Hopi silversmiths to develop their own style of jewelry with designs and techniques that would be unique to the Hopis. World War II intervened in those plans, and it was not until 1947 that the G.I. training program for veterans helped sponsor a silversmithing course at the Hopi Guild on Second Mesa. Out of this program came many new designs and techniques, most notably the overlay style considered characteristically Hopi. Fred Kabotie (standing, top left) taught artistic design and he encouraged the jewelers to look to traditional Hopi images for inspiration. Hopi weaves, baskets, and even clan symbols were used as design concepts for the silversmiths.

These early silversmiths hold posters displaying Hopi designs. Seated in the first row are instructors Fred Kabotie (left) and Paul Saufkie. From left to right are (second row) Arthur Yowytewa, Harold Koruh, Starlie Lomayaktewa, Dean Siwingymptewa, Bert Puhuyestiwa, and Clarence Lomayestewa; (third row) Herbert Komayouse, Orville Talayumptewa, LaVerne Siwingymptewa, Henry Polinigyouma, Kirkland Lomawaima, and Valjean Joshevema Sr.

Seven

The Hopi Tribe Today

From the time of the earliest contact with the U.S. government in the late 1800s, bureaucrats in Washington imposed Anglo visions of education, government, housing, and lifestyle upon the Hopi people. Christian missionaries worked with the support of the government to convert and lure the Hopis away from their traditional religion. A succession of domineering and unsympathetic supervisors appointed by the Bureau of Indian Affairs governed the Hopis with supreme power, at times with cruelty and force. Traditional dances and ceremonies were banned, resistors were jailed, and in many instances, even the traditional long hair of the Hopi men was cut off. By the late 1920s, growing support from outside journalists and writers, politicians, and supportive groups such as the Indian Welfare League and the National Association to Help the Indian, even the General Federation of Women's Clubs, began to force a change in government policy.

The Wheeler-Howard Act, known as the Indian Reorganization Act, was passed in 1934, marking a turn in the government's policies toward Native American education, land ownership, and self-determination, and in 1937, Commissioner John Collier signed his approval of the Constitution and By-Laws of the Hopi Tribe. This document imposed a Hopi Council and Anglo-style government upon the Hopis, never mind that the Hopi had existed for centuries with their own system of village chiefs, religious society leaders, and clan associations. Today the Hopi Tribal Council mediates and resolves issues with the U.S. government and the outside world, as well as making laws and overseeing tribal business. Even with the Tribal Council, each village is autonomous with its own social, religious, and political organizations, as well as a *kikmongwi*, "village chief." Through traditional and modern forms of self-determination, the Hopi Tribe today is thriving and prosperous.

Officials meet at the Hopi Court in session at Keams Canyon. Respected Hopi elders work in committees to give input in traditional Hopi law as it is applied in contemporary times. Sam Shingoitewa is seated to the left of the unidentified woman behind the typewriter. Judge Irving Pavanale is to the right

Hopi Tribal Council members are elected to represent each village and district on the Hopi Reservation. From left to right are Percy Lomaquaptewa, Abbott Sekaquaptewa (a former tribal chairman), and Starlie Lomayaktewa. (Courtesy of Hopi Cultural Preservation Office.)

Eugene Sekaquaptewa (left) and Jimmy Hohanie served as tribal officials. (Courtesy of Hopi Cultural Preservation Office.)

The U.S. government established Hopi tribal boundaries in 1882 but consistently reduced that land over the years, allotting more and more traditional Hopi land to the Navajo Tribe, in the mistaken belief that they were all "one Indian tribe." Hopi leaders worked for decades to restore that land to the Hopi people through federal lawsuits, hundreds of meetings with government officials and Hopi and Navajo farmers and ranchers, and negotiations with Navajo officials to redraw the boundaries. From left to right are Abbott Sekaquaptewa, Dewey Healing, and Nathan Begay. (Courtesy of Hopi Cultural Preservation Office.)

The Hopi people have a long tradition of brave and distinguished service in the U.S. Armed Forces. During World War II, 11 Hopi men worked for the U.S. Army as code talkers. Using the Hopi language, they developed a secret language, such as using the Hopi word for hawk to indicate a certain kind of airplane, the word for egg signaled a bomb, and so on. This secret code used by the Hopi code talkers was never deciphered by enemy troops. Travis S. Yaiva (below, far left) is the last living Hopi code talker. The world also knows of the young Hopi woman from Tuba City, Arizona, who became a heroine of the war in Iraq. In 2003, Lori Piestewa, whose Hopi name, Qötsahonmana, means "White Bear Girl," died in battle and became the first Native American woman killed in combat. (Courtesy of Hopi Cultural Preservation Office.)

BIBLIOGRAPHY

Blue, Martha. *Indian Trader: The Life and Times of J. L. Hubbell.* Walnut, CA: Kiva Publishing, 2000.

Davis, Carolyn O'Bagy. *Hopi Quilting: Stitched Traditions from an Ancient Community.* Tucson, AZ: Sanpete Publications, 1997.

Hagerty, Donald J. *Desert Dreams: The Art and Life of Maynard Dixon.* Layton, UT: Gibbs Smith, 1993.

James, Harry C. *Pages from Hopi History.* Tucson, AZ: The University of Arizona Press, 1994.

Johnson, Ginger. *Kate T. Cory: Artist of Arizona 1861–1958.* Prescott, AZ: Smoki Museum, 1996.

Kabotie, Fred, and Bill Bellknap. *Fred Kabotie Hopi Indian Artist.* Flagstaff, AZ: Northland Press, 1977.

Kavena, Juanita Tiger. *Hopi Cookery.* Tucson, AZ: The University of Arizona Press, 1992.

Kramer, Barbara. *Nampeyo and Her Pottery.* Albuquerque, NM: University of New Mexico Press, 1996.

Moody, William A. *Years in the Sheaf.* Salt Lake City, UT: Granite Publishing Company, 1959.

Nabokov, Peter. *Indian Running.* Santa Barbara, CA: Capra Press, 1981.

Rhodes, Robert W. *Hopi Wicker Plaques and Baskets.* Atglen, PA: Schiffer Publishing, 2007.

Schaaf, Gregory. *Hopi-Tewa Pottery 500 Artist Biographies.* Santa Fe, NM: CIAC Press, 1998.

Silas, Anna. *Journey to Hopi Land.* Tucson, AZ: Rio Nuevo Publishers, 2006.

Teiwes, Helga. *Hopi Basket Weaving: Artistry in Natural Fibers.* Tucson, AZ: The University of Arizona. 1996.

Wright, Margaret Nickelson. *Hopi Silver: The History and Hallmarks of Hopi Silversmithing.* Albuquerque, NM: University of New Mexico Press, 2003.

www.arcadiapublishing.com

Discover books about the town where you grew up, the cities where your friends and families live, the town where your parents met, or even that retirement spot you've been dreaming about. Our Web site provides history lovers with exclusive deals, advanced notification about new titles, e-mail alerts of author events, and much more.

MADE IN THE USA

Arcadia Publishing, the leading local history publisher in the United States, is committed to making history accessible and meaningful through publishing books that celebrate and preserve the heritage of America's people and places. Consistent with our mission to preserve history on a local level, this book was printed in South Carolina on American-made paper and manufactured entirely in the United States.

This book carries the accredited Forest Stewardship Council (FSC) label and is printed on 100 percent FSC-certified paper. Products carrying the FSC label are independently certified to assure consumers that they come from forests that are managed to meet the social, economic, and ecological needs of present and future generations.

FSC
Mixed Sources
Product group from well-managed forests and other controlled sources

Cert no. SW-COC-001530
www.fsc.org
© 1996 Forest Stewardship Council

Find Your Place in History.